SMALL WORLDS

Best regards!
MG Wheel— 98

CLUE: How's this for openers?

SMALL WORLDS
A Book of Photo Puzzles

MATTHEW WHEELER

ARSENAL PULP PRESS
Vancouver

SMALL WORLDS
Copyright © 1998 by Matthew Wheeler

ARSENAL PULP PRESS
103-1014 Homer Street
Vancouver, B.C.
Canada V6B 2W9

The publisher gratefully acknowledges the assistance of the Book Publishing Industry Development Program.

Designed and typeset by the Vancouver Desktop Publishing Centre
Printed and bound in Canada

CANADIAN CATALOGUING IN PUBLICATION DATA:
Wheeler, Matthew.
Small worlds

 ISBN 1-55152-054-0

 1. Picture puzzles. 2. Photography, Close-up. I. Title.
GV15071.P47W53 1998 793.73 C98-910077-4

Dedicated to my parents, Marilyn and John, who gave me vision and so much more.

Many thanks to Maureen Brownlee for her encouragement and first publishing a series of these photographs in *The Valley Sentinel*; Marie Nagel for her support and publishing part of the series in the *Wells Community News*; my mother Marilyn Wheeler for extraordinary patience in suffering this long painful birth; Alison Marchant for lending many subjects, ideas, and time; my brother John Wheeler for his ideas and objective views over the years; and to the many uncelebrated designers, inventors, and product-makers whose work appears on these pages.

I also thank Peter Amyoony; Norma Bend; Archie McLean and Jim Turner at Firth Hollin Resource Science Corp.; Glen Frear; Linda Fry; Steve Gillette; Robert Green; Steven Green; Mark Hoddinott; Bill Horne; Rozlyn Jacques; Claire Kujundzic; Matthew Lea; Donna and Rodger Peterson and Neil Rideout at McBride Office Services; Carolyn McKenzie; Rose and Kevin O'Brien; Heather Wheeler; Paul and Tammy Wildeman; and to the fans of the series.

Special thanks to Stephen Osborne, and to the team at Arsenal Pulp Press: Brian Lam, Blaine Kyllo, and Patty Osborne, for patiently and enthusiastically taking on this project.

CLUE: A discarded solar panel

SOLUTION: Aspen leaf

INTRODUCTION

Have you ever wondered how many different bits and pieces, how many separate artifacts, we depend on for modern living? The outward appearance of most objects varies greatly according to their design and decoration. Most of the artifacts in this book do not exist for their looks, however, but for the tasks they perform. These functions make them universal and familiar—they are things we know well and may handle often, sometimes on a daily basis. So, too, the organic and inanimate subjects here are shaped by forces, both natural and human, and display characteristic forms and patterns. Fragments of these things, then, extracted from their surroundings, become strange new worlds unto themselves. *Small Worlds* offers glimpses of these fragments—the asteroid belt of the places where we live, work, and play. Since childhood, I've loved exploring miniature scenes with my sketchbook and camera; I've learned the world is a fascinating place to see up close. I hope this book adds to your enjoyment of it.

—*MATTHEW WHEELER*
Robson Valley, B.C.
March 1998

ABOUT *SMALL WORLDS*

1. The aim of the game is to recognize what is in the photos.

2. Most of the images are of objects we are all familiar with.

3. If you're stumped, try the clues beside the photos.

4. Solutions can be found beginning on page 116, but remember, there's no turning back once you've read them. The fun is in that moment of recognition!

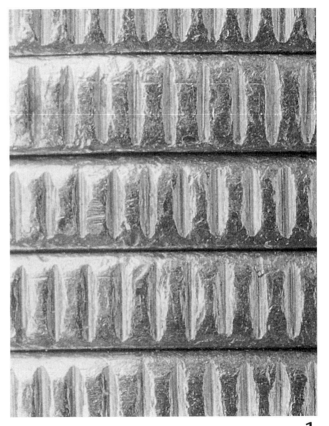

Will help you change the world.

SMALL WORLD 1

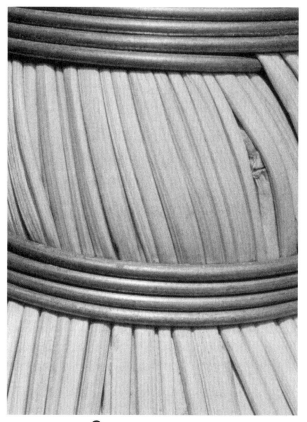

SMALL WORLD 2

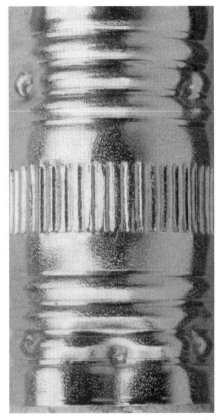

A rubber container.

SMALL WORLD **3**

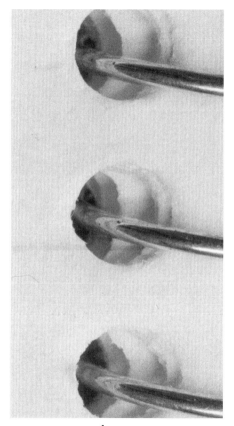

SMALL WORLD 4

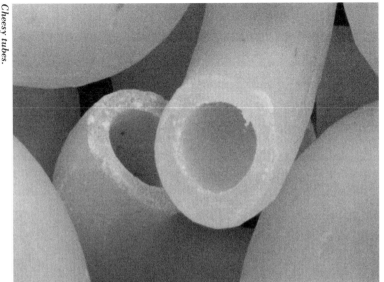

Cheesy tubes.

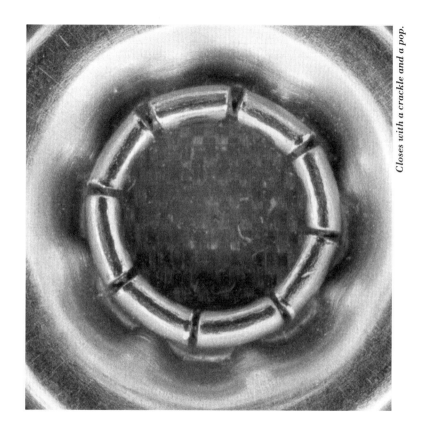

Closes with a crackle and a pop.

SMALL WORLD **6**

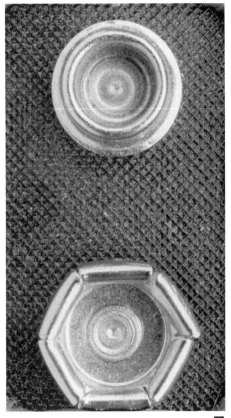

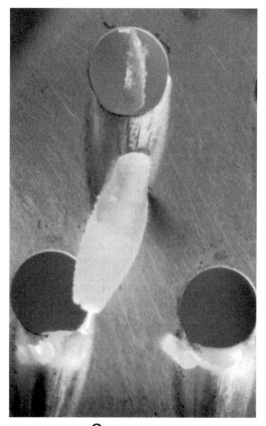

SMALL WORLD **8**

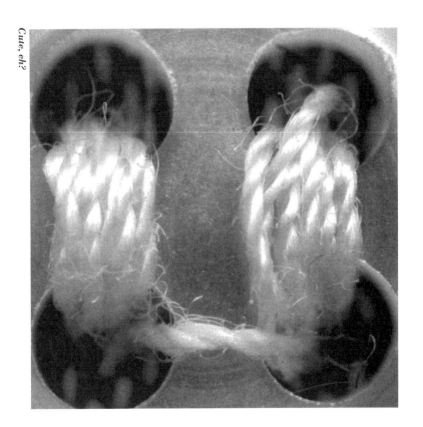

Cute, eh?

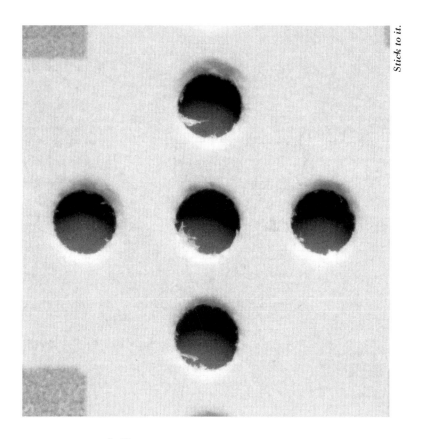

Stick to it.

SMALL WORLD 10

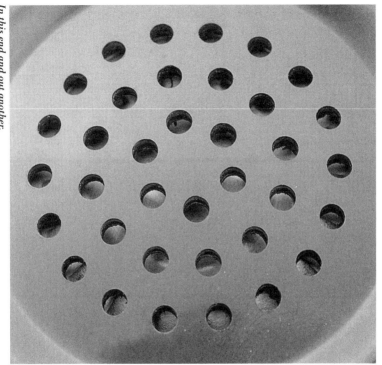

SMALL WORLD 11

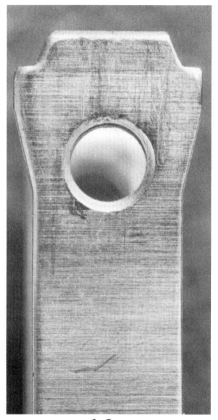

SMALL WORLD 12

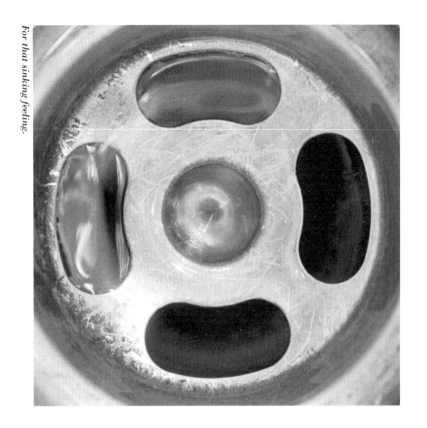

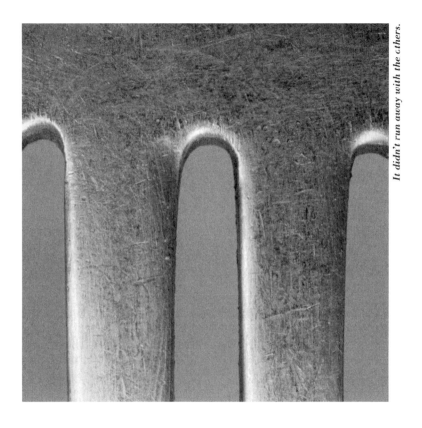

It didn't run away with the others.

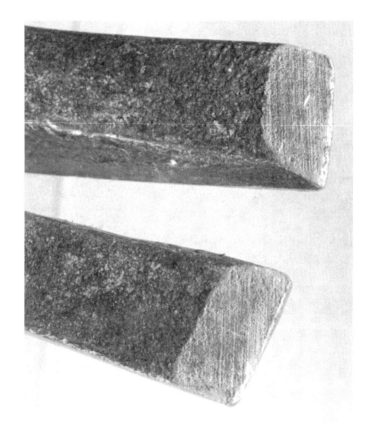

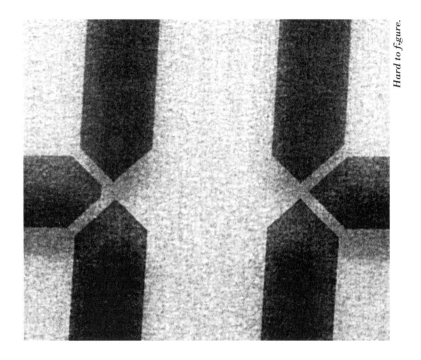

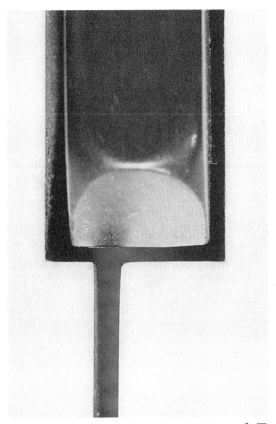

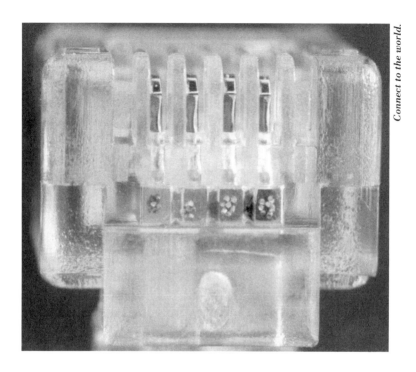

SMALL WORLD 18

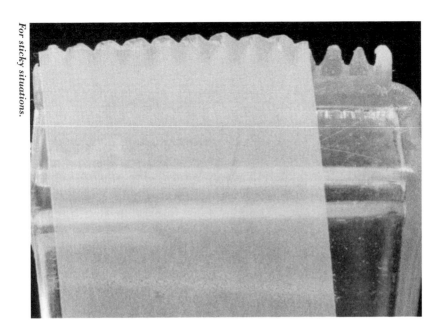

For sticky situations.

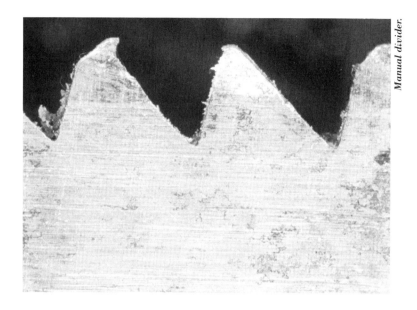

Manual divider.

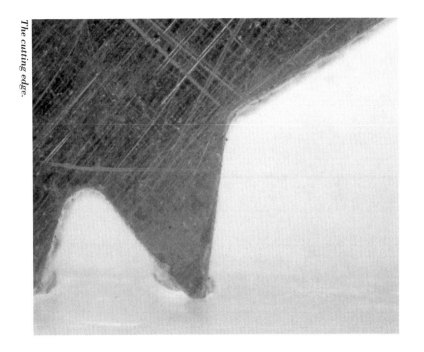

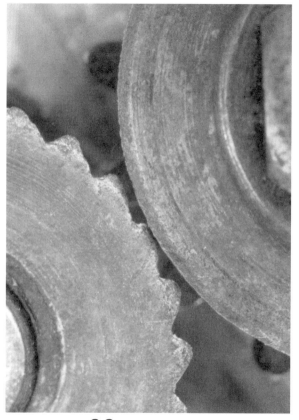

SMALL WORLD 22

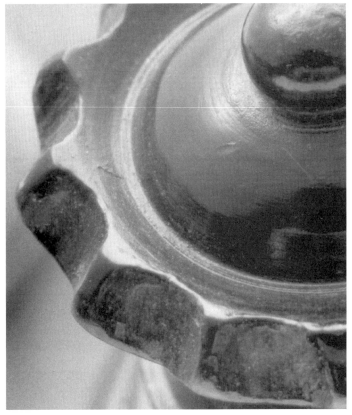

Regal head in play.

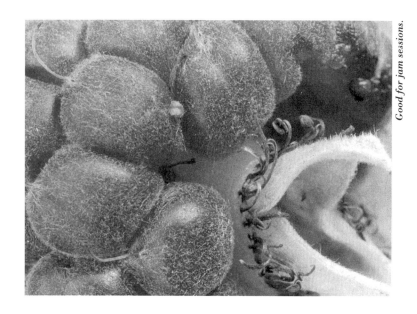

Good for jam sessions.

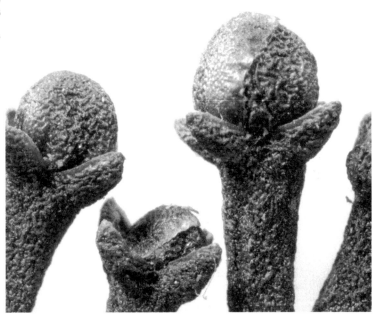

Spiky spice.

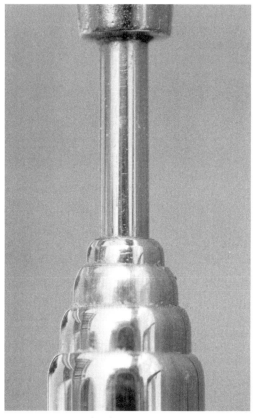

SMALL WORLD **26**

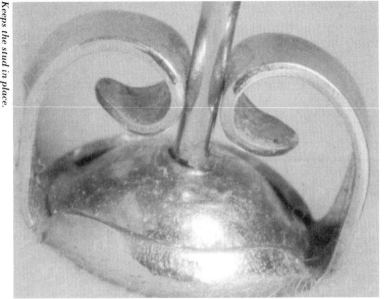

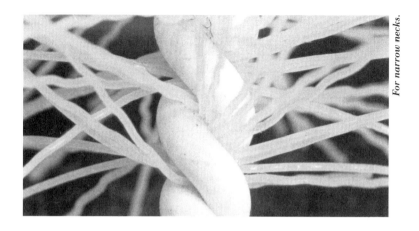

For narrow necks.

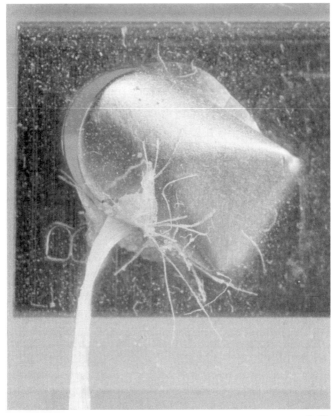

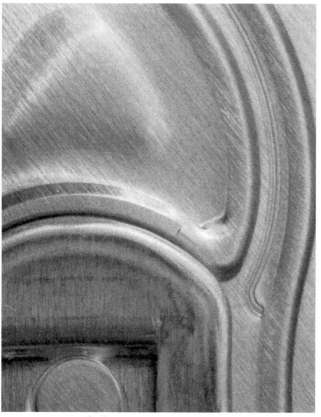

Pull for a pop.

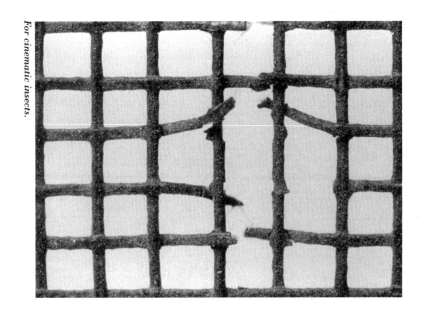

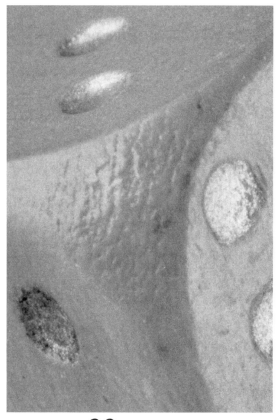

It's all in the throw.

SMALL WORLD **32**

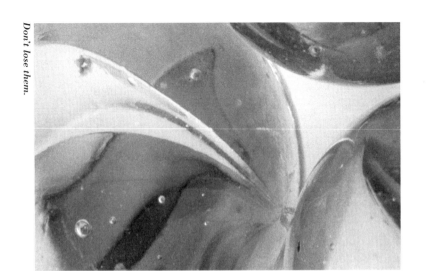

Don't lose them.

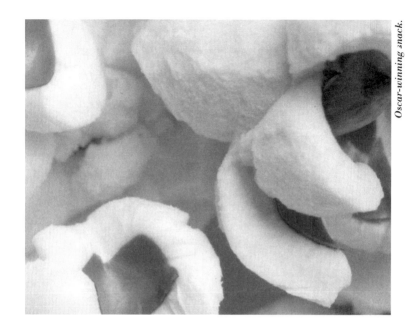

Oscar-winning snack.

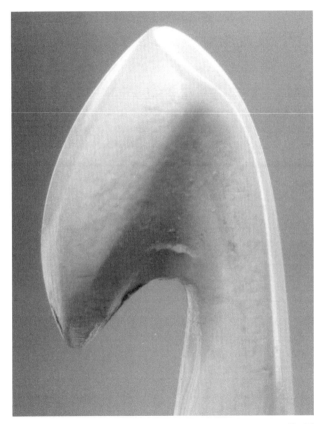

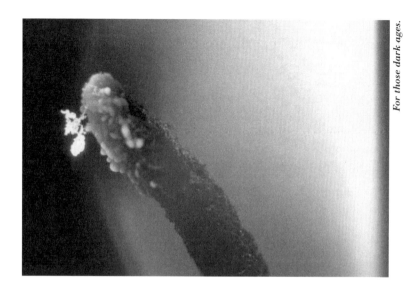

SMALL WORLD 36

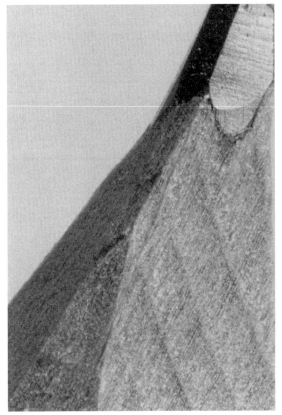

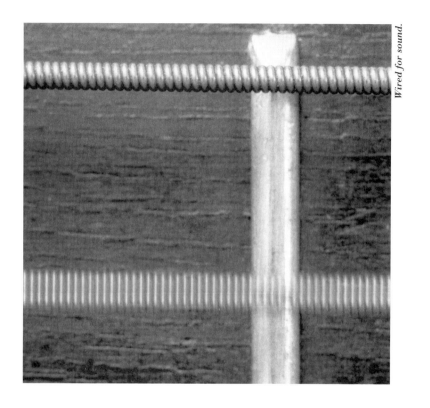

SMALL WORLD **38**

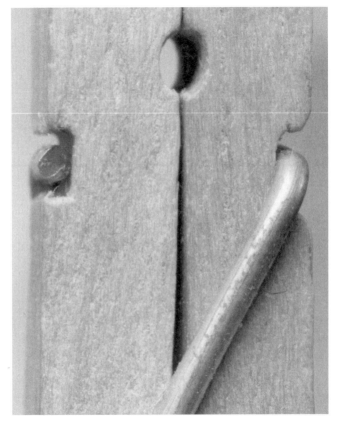

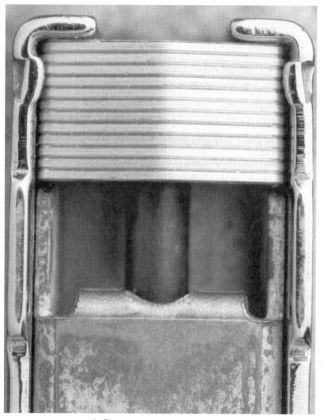

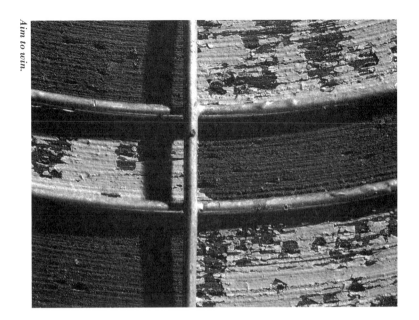

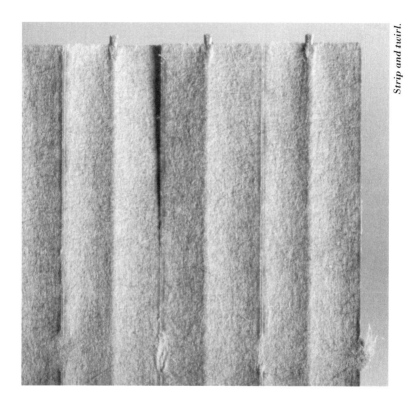

SMALL WORLD 42

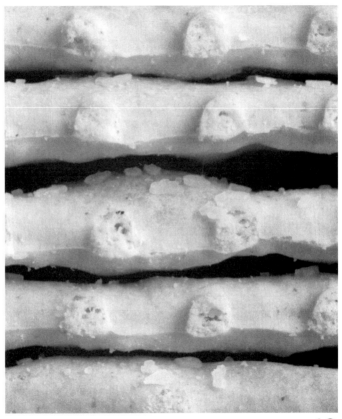

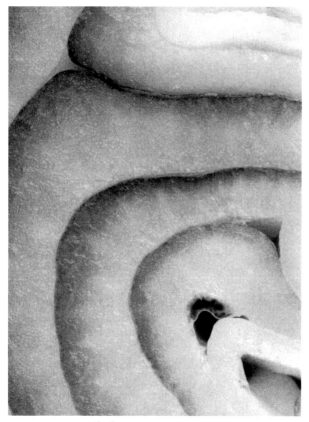

A crying game.

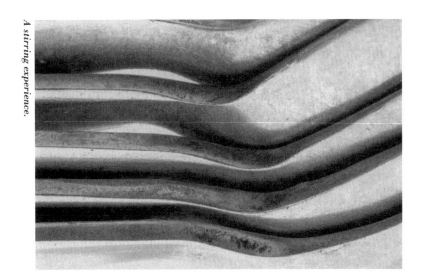

A stirring experience.

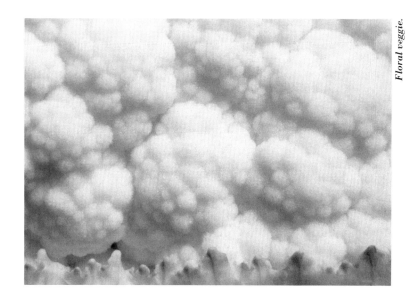

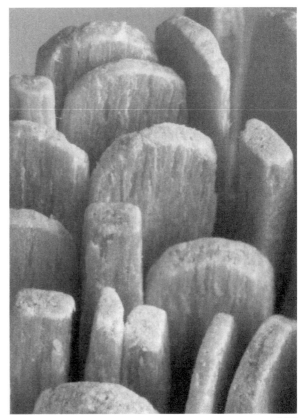

Lumber for your mouth.

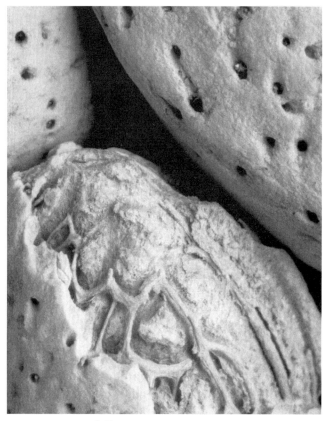

SMALL WORLD **48**

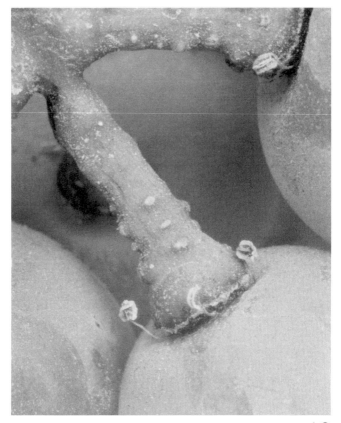

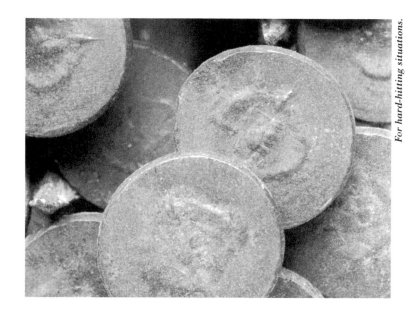

SMALL WORLD 50

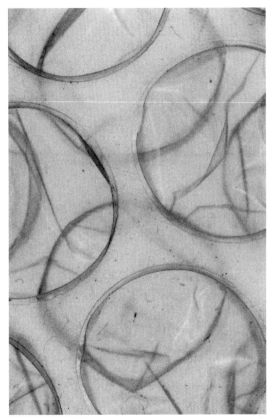

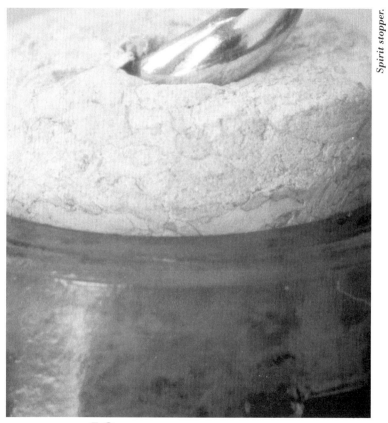

Spirit stopper.

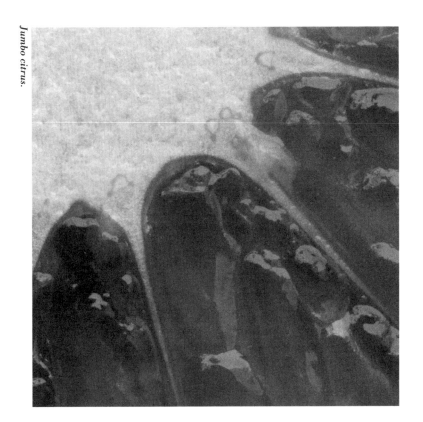

Jumbo citrus.

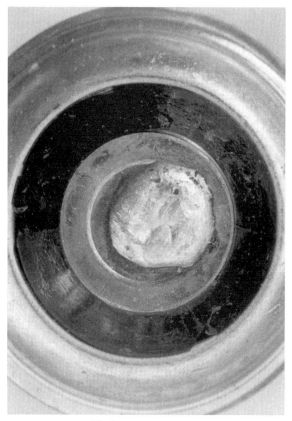

Revolves for sound.

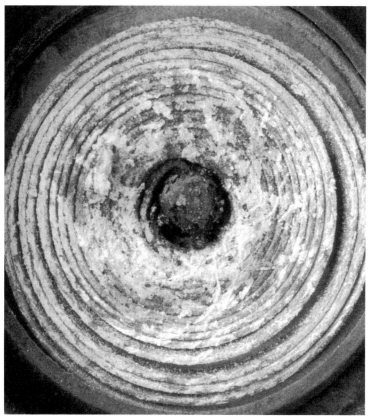

SMALL WORLD **56**

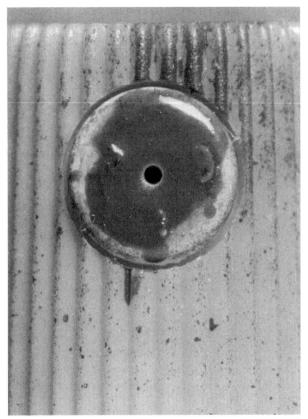

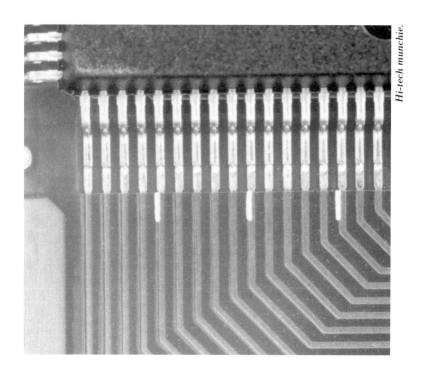

Hi-tech munchie.

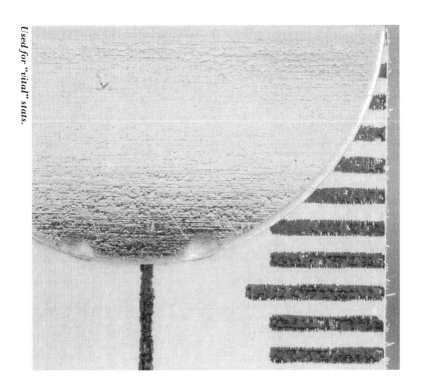

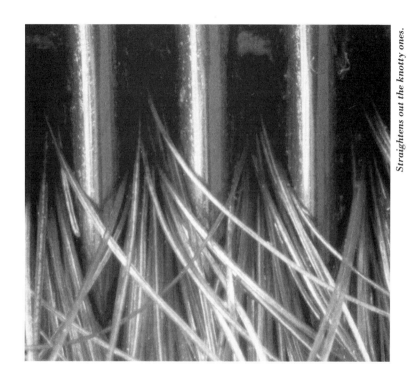

Straightens out the knotty ones.

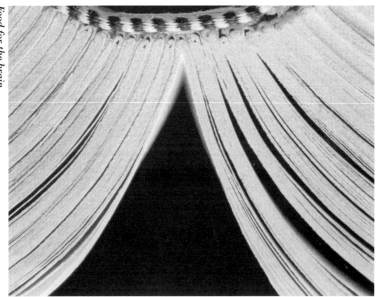

Food for the brain.

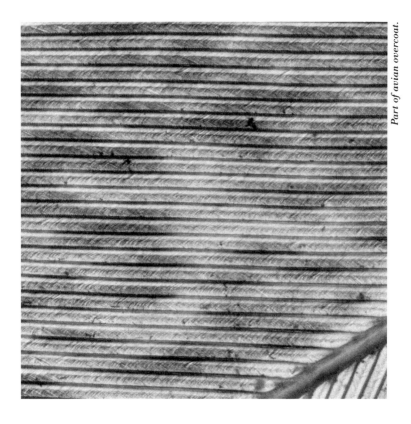

Part of avian overcoat.

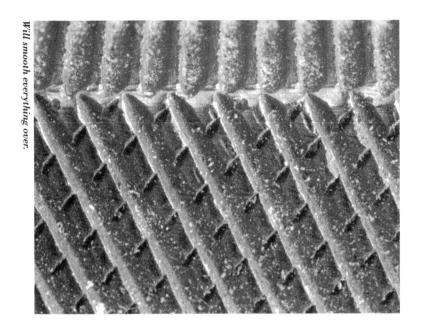

Will smooth everything over.

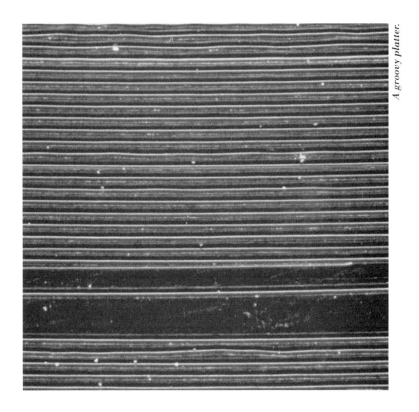

A groovy platter.

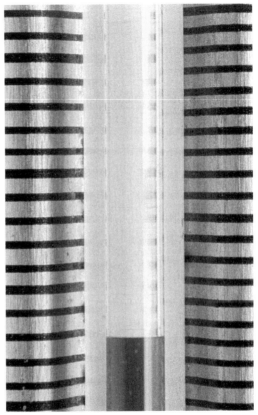

If this is rising, you're getting warm.

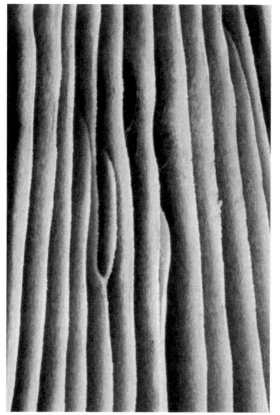

Edible room.

SMALL WORLD **66**

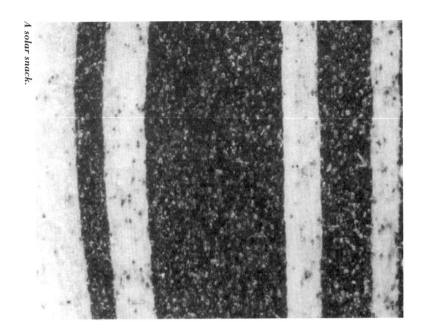

A solar snack.

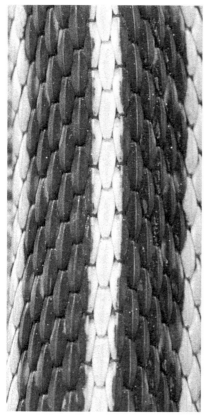

Fork-fronted slider.

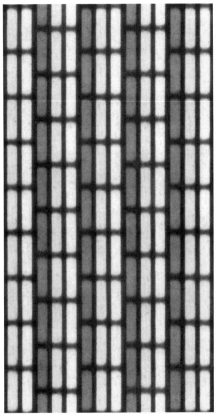

You're too close if it looks like this.

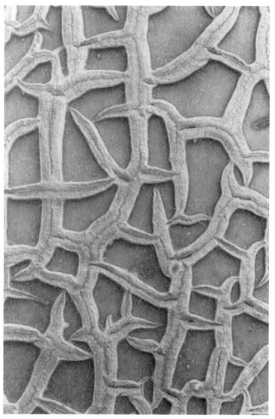

A fruity landscape.

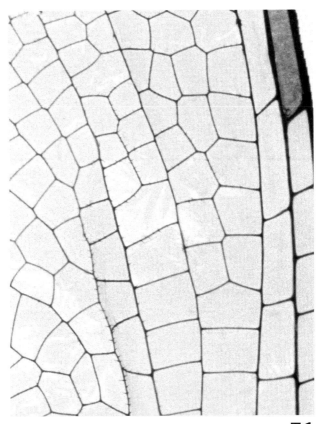

Belongs to an aerodynamic expert.

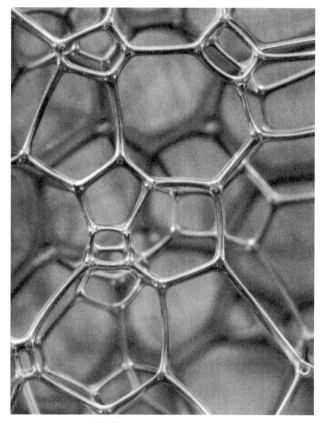

Kitchen sink drama.

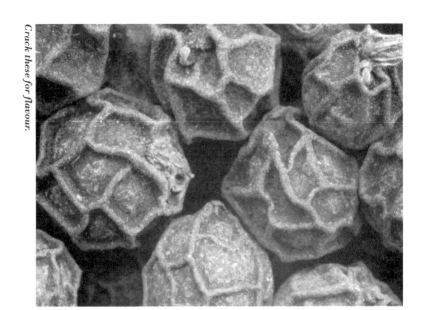

Crack these for flavour.

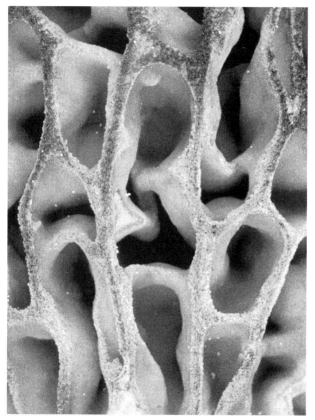

Wild delicacy, more or less.

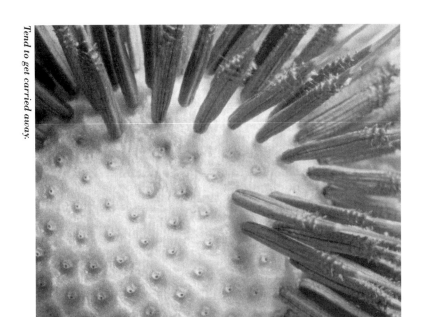

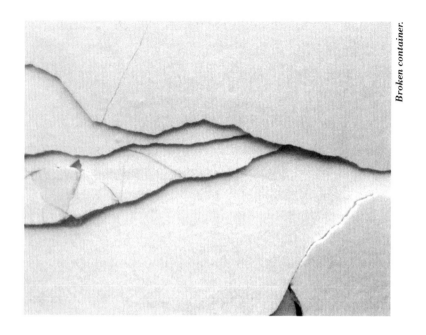

Broken container.

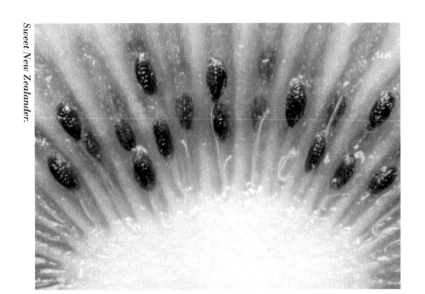

Sweet New Zealander.

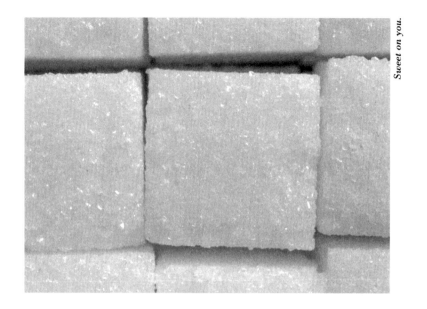

Sweet on you.

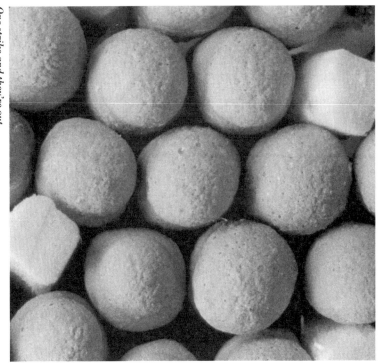

One strike and they're out.

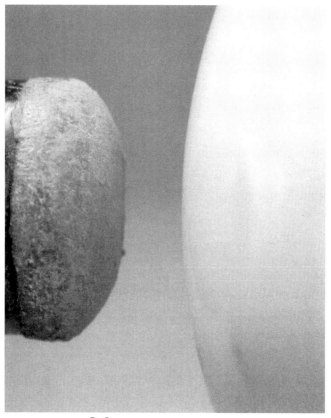

SMALL WORLD 80

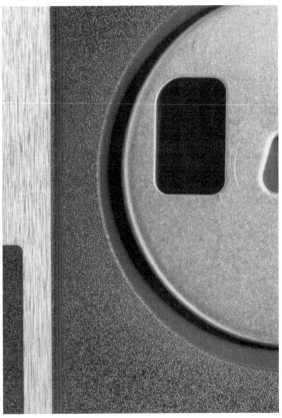

File holder.

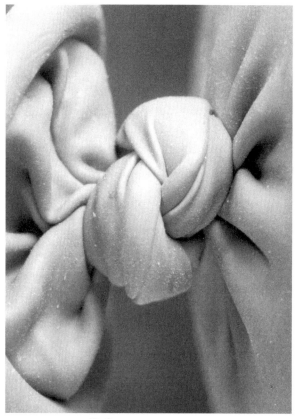

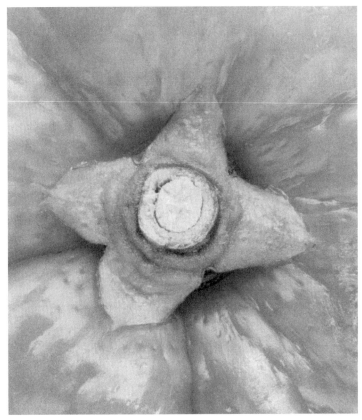

Juice cap.

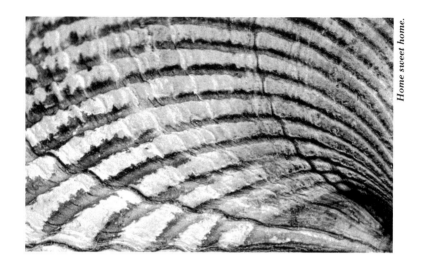

Home sweet home.

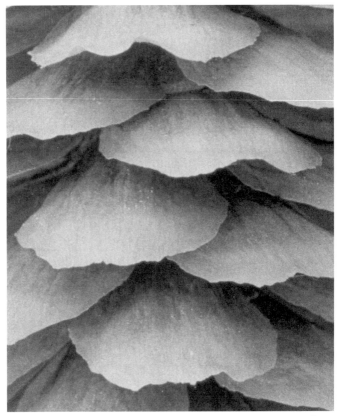

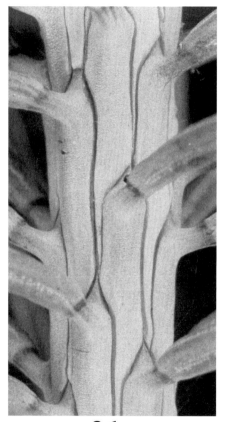

Christmas ornament holder.

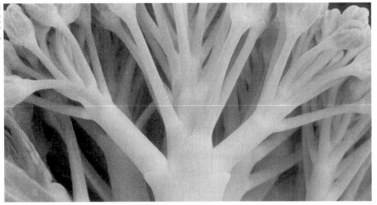

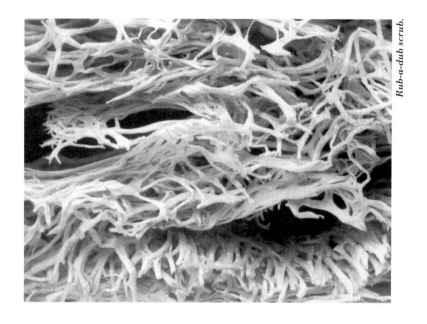

SMALL WORLD **88**

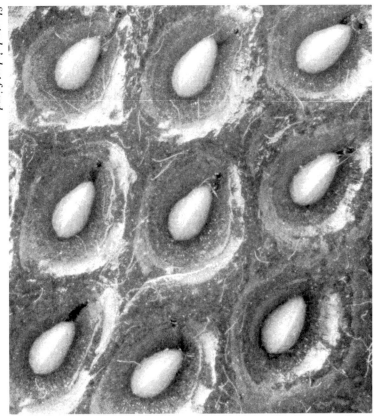

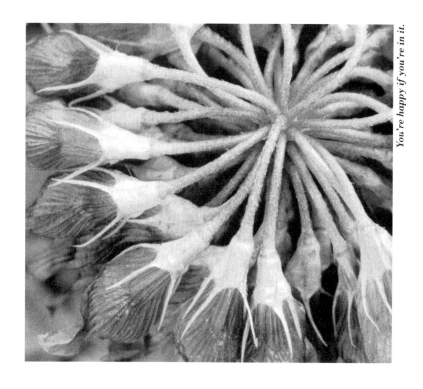

You're happy if you're in it.

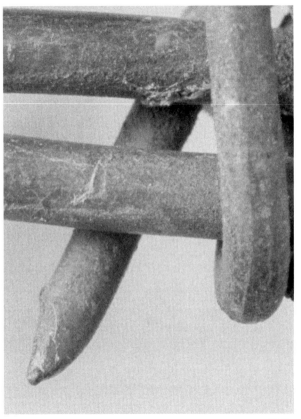

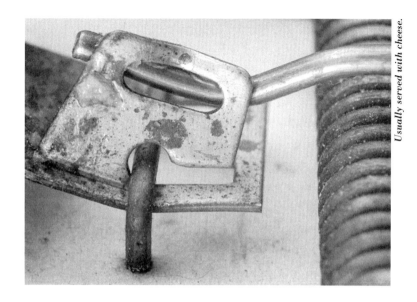

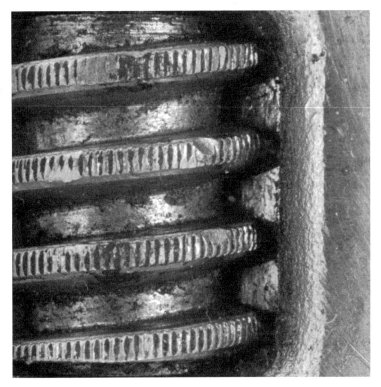

One size twists all.

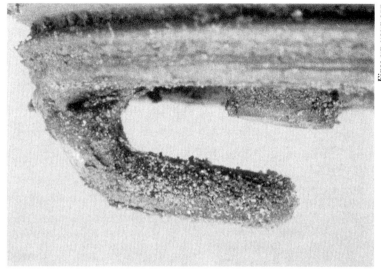

Fires up your car.

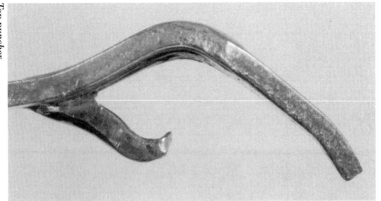

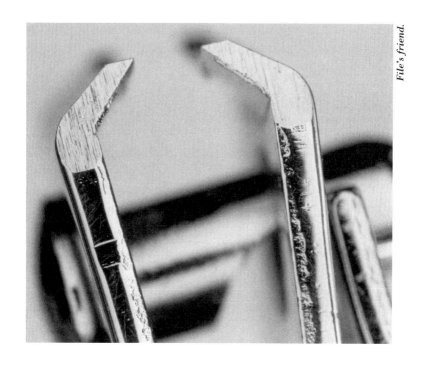

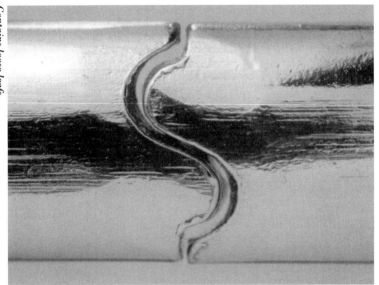

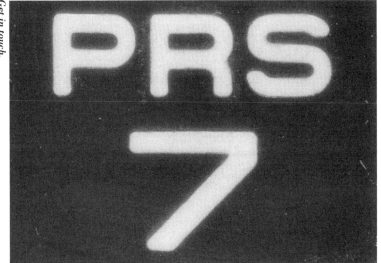

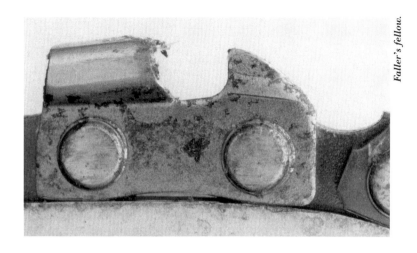

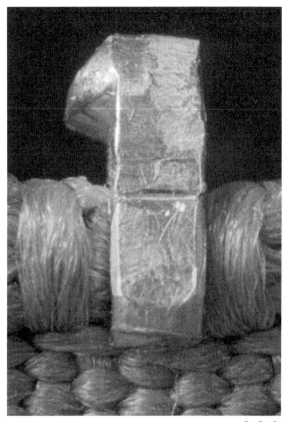

Don't get caught flying low.

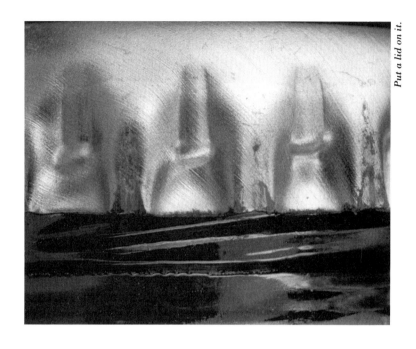

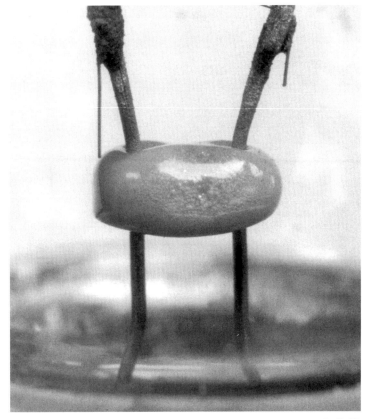

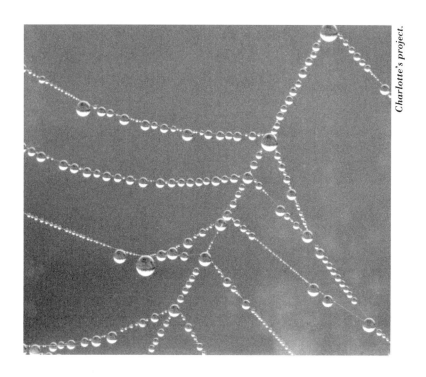

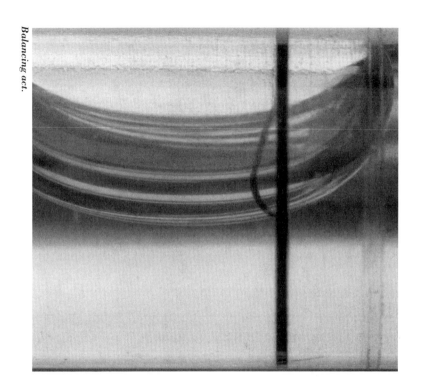
Balancing act.

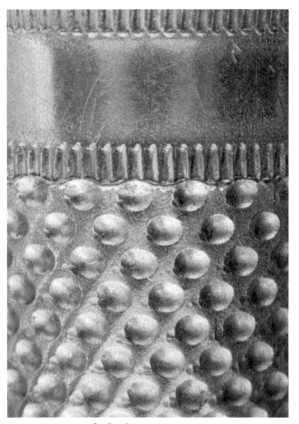

SMALL WORLD 106

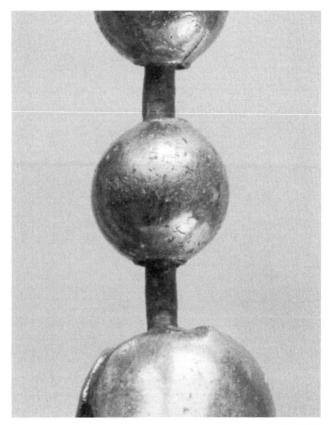

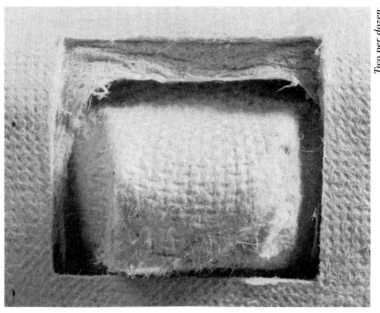

Two per dozen.

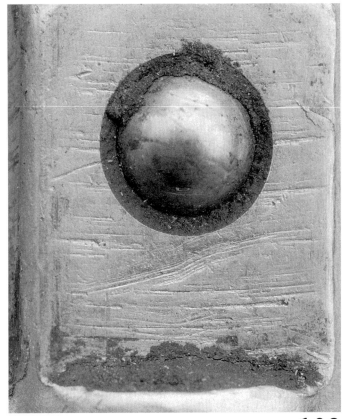

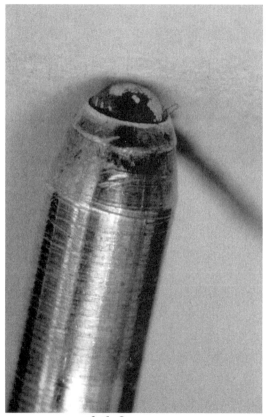

SMALL WORLD 110

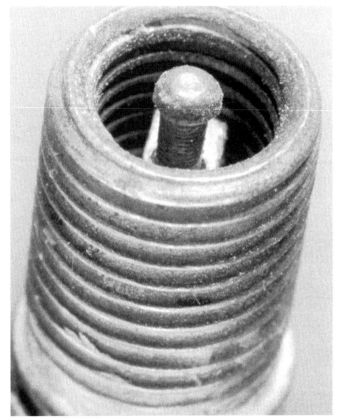

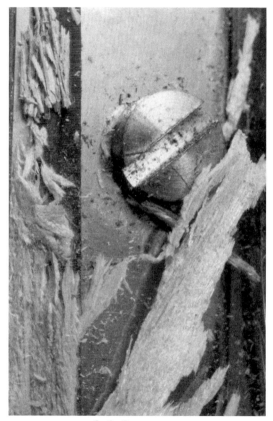

To make too fine a point of it.

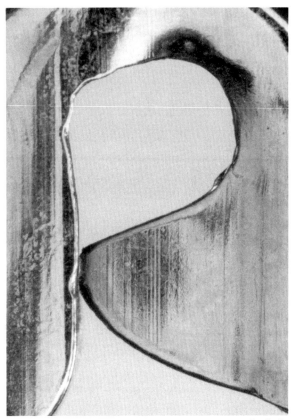

For prickly situations.

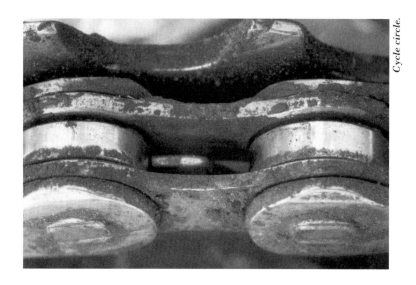

SOLUTIONS

1 Will help you change the world. *A stack of quarters*

2 Dust bunnies beware. *A straw broom*

3 A rubber container. *Eraser holder on a pencil*

4 Holds those thoughts. *Spiral-bound notebook*

5 Cheesy tubes. *Pieces of macaroni*

6 Closes with a crackle and a pop. *Snap fastener*

7 Power to the player. *Connectors on a nine-volt battery*

8 Shreds your ched. *Cheese grater*

9 Cute, eh? *Button*

10 Stick to it. *Corners of four postage stamps*

11 In this end and out another. *Telephone receiver*

12 Current connectors. *Electrical plug prongs*

13 For that sinking feeling. *Kitchen sink drain*

14 It didn't run away with the others. *Table fork*

15 Cat's tool. *Hammer claw*

16 Hard to figure. *Liquid crystal numbers*

17 Used to unlock sound. *Piano keys*

18 Connect to the world. *Telephone connector*

19 For sticky situations. *Plastic tape dispenser*

20 Manual divider. *Handsaw*

21 The cutting edge. *Tip of a figure skate blade*

22 Recycle after using this. *Rotary can opener*

23 Regal head in play. *Chess piece; queen*

24 Good for jam sessions. *Raspberry*

25 Spiky spice. *Cloves*

26 Wide receiver. *Collapsible antenna*

27 Keeps the stud in place. *Earring back*

28 For narrow necks. *Bottle-cleaning brush*

29 Use it or lose 'em. *Dental floss dispenser*

30 Pull for a pop. *Pop can*

31 For cinematic insects. *Fly screen*

32 It's all in the throw. *A die*

33 Don't lose them. *Marbles*

34 Oscar-winning snack. *Popped corn*

35 For a good yarn. *Crochet hook*

36 For those Dark Ages. *Burning candle wick*

37 The write stuff. *Pencil tip*

38 Wired for sound. *Guitar strings*

39 For sheets to the wind. *Clothes peg*

40 Double piercing. *Stapler*

41 Aim to win. *Dartboard*

42 Strip and twirl. *Twist ties*

43 Cheese platters. *Stack of crackers*

44 A crying game. *Onion*

45 A stirring experience. *Spoons*

46 Floral veggie. *Cauliflower*

47 Lumber for your mouth. *Toothpicks*

48 Marzipan in the rough. *Almonds in shell*

49 No wrath here. *Grapes*

50 For hard-hitting situations. *Handful of nails*

51 An airy experience. *Bubble packing*

52 Spirit stopper. *Cork in bottle*

53 Jumbo citrus. *Grapefruit*

54 A brilliant invention. *Light bulb*

55 Revolves for sound. *Audiocassette tape sprocket*

56 Will light your fire. *Car lighter*

57 It's a blast. *Spray can nozzle*

58 Hi-tech munchie. *Computer chip*

59 Used for "vital" stats. *Cloth tape measure*

60 Straightens out the knotty ones. *Hair in comb*

61 Food for the brain. *Hardcover book*

62 Part of avian overcoat. *Feather*

63 Will smooth everything over. *Metal file*

64 A groovy platter. *LP record*

65 If this is rising, you're getting warm. *Thermometer*

66 Edible room. *Common field mushroom*

67 A solar snack. *Sunflower seed case*

68 Fork-fronted slider. *Snake*

69 You're too close if it looks like this. *Television screen*

70 A fruity landscape. *Cantaloupe*

71 Belongs to an aerodynamic expert. *Dragonfly wing*

72 Kitchen sink drama. *Dishwashing bubbles*

73 Crack these for flavour. *Peppercorns*

74 Wild delicacy, more or less. *Morel mushroom*

75 Tend to get carried away. *Dandelion seed head*

76 Broken containers. *Stack of egg shells*

77 Sweet New Zealander. *Kiwi fruit*

78 Sweet on you. *Sugar cubes*

79 One strike and they're out. *Pile of matches*

80 Ready to roll. *Billiard cue and ball*

81 File holder. *Floppy disk*

82 Blow hole. *Balloon knot*

83 Juice cap. *Orange top*

84 Home sweet home. *Clam shell*

85 Squirrel this away. *Spruce cone*

86 Christmas ornament holder. *Spruce tree twig*

87 Edible bouquet. *Broccoli*

88 Rub-a-dub scrub. *Loofah sponge*

89 Shortcake's best friend. *Ripe strawberry*

90 You're happy if you're in it. *Clover*

91 Part of a prickly perimeter. *Barbed wire*

92 Usually served with cheese. *Mouse trap*

93 One size twists all. *Adjustable wrench*

94 Fires up your car. *Spark plug*

95 Top puncher. *Manual can opener*

96 File's friend. *Nail clippers*

97 Contains loose leafs. *Three-ring binder*

98 Open wide. *Spout on a dairy or juice carton*

99 Get in touch. *Telephone button*

100 Faller's fellow. *Chainsaw*

101 Don't get caught flying low. *Zipper*

102 Put a lid on it. *Twist-off bottle top*

103 To light your path. *Flashlight bulb*

104 Charlotte's project. *Spider web*

105 Balancing act. *Carpenter's level*

106 Digital protector. *Thimble*

107 Use it or lose it. *Sink, light, or key chain*

108 Two per dozen. *Egg carton fastener*

109 Sock it to 'em. *Socket wrench*

110 Old-fashioned recorder. *Ball point pen on paper*

111 Malfunction equals flatulence. *Tire valve*

112 To make too fine a point of it. *Manual pencil sharpener*

113 For prickly situations. *Safety pin*

114 Cycle circle. *Bicycle chain*

115 Packs 'em in. *Cardboard*